Duchamp's Last Day

David Zwirner Books

ekphrasis

Duchamp's Last Day
Donald Shambroom

Contents

Duchamp's Last Day

In Paris, in the early afternoon of October 1, 1968, the last day of his life, Marcel Duchamp made a trip to the Vuibert bookshop on the boulevard Saint-Germain. The artist who had stunned the world with his *Nude Descending a Staircase, No. 2* (1912), and invented the readymade by signing a snow shovel (1915), was returning to the shop to gather materials he had ordered for a final playful assault on everyday experience, common sense, and three-dimensional space. He needed the book *Geometric Anaglyphs* to complete a printed image he was making of an unusual fireplace, to be included in a deluxe edition of his complete works. Geometric anaglyphs are drawings of solids, cubes, and spheres in which configurations of red lines are superimposed on drawings in blue, slightly offset and viewed from a different angle. When looked at through cardboard 3-D glasses—one lens red, the other blue—the drawings pop into life. Duchamp's fireplace was to be shaped like a section of a giant standing funnel, large end down and wedged into a corner of the living room in an apartment in Cadaqués, a fishing village on the Spanish coast north of Barcelona. He and his wife, Teeny, spent summers there. To provide a guide for a mason, Duchamp had first constructed, in place, a minimal sculpture using rigid wire to delineate the horizontal joints of its rounded surface, and string to suggest the upward curves. Following the lines of his installation, he then produced a careful anaglyph. But he needed the 3-D glasses to see the illusion.

A week earlier, the eighty-one-year-old Duchamp had gone walking on the boulevard, hoping to find the bookshop he had last visited in the 1930s. He walked briskly, carrying himself with the bearing of a much younger man. He was thrilled to discover that Vuibert was just where he had thought, and that it still carried *Geometric Anaglyphs*, now in its fourth edition, 3-D glasses included. He bought the book and ordered a dozen more.

Throughout his career, Duchamp had been intrigued by the visual transition from the second to the third dimension, and how, utilizing what he termed "playful physics," you could imply the unimaginable fourth dimension. Before the First World War, when cubism began to tear apart the picture plane, Gertrude Stein singled out Duchamp as the young man who "talks very urgently about the fourth dimension." If you freed your imagination and paid close attention, it was possible to take a mental leap from a flat shadow on the ground to the full-fledged figure that projected it. This could give the leap psychic momentum, and you might find yourself teetering on the edge of a fourth dimension. Duchamp was giving it another shot. Start with a simple line drawing in blue and red pencil, don the colored glasses, and there it is! A working 3-D fireplace. There, did you see just beyond it? Did you get a glimpse of another spatial realm as you passed the chimney?

Almost certainly not. For Duchamp, the playful effort was what counted. He had been playing like this for his entire life, conjuring forms that defied the solidity of

three spatial axes. His new fireplace was a fresh variation on a decades-old notion, a fleeting idea whose subject was the capture of that which is fleeting. At twenty-five, he had written on a torn scrap of paper:

> Take one cubic centimeter of
> tobacco smoke and paint
> the exterior and interior surfaces
> a waterproof color.[1]

Duchamp had a habit of writing down mental images like this, of mixing science with humorous delirium. He never got himself a notebook, but when an idea came to mind, he looked around for something to write on—a menu, a letter, or a gas bill—and tore off a small piece. Each note had a different shape, and when it came time to publish his thoughts, he reproduced them as lithographs on the finest paper, using precisely cut zinc templates to tear the sheets and match the originals. He made three hundred sets of one hundred notes and placed each set in random order in his *Green Box* of 1934. Thirty-two years later, the publication of *The White Box* expanded this opening into the artist's mind.

At the bookshop, one more surprise awaited Duchamp: a newly published volume of stories by Alphonse Allais, the comic genius of the Paris café scene at the end of the nineteenth century. Allais wrote stories of just a page or two. If there is such a thing as a funny bone, he hit it every time. He presented his tales as news dispatches or

neighborhood gossip. He skewered everyone, including himself, along with the French language, and always with democratic good cheer. But the body count was high. He concocted frequent and ingenious deaths. His posting in the personal column of a real newspaper reads as follows:

> To M.V.P.—Well, it's your own fault. If you hadn't tried to impress your doctor by telling him you were a solicitor, instead of admitting that you really worked as a fire-eater in a traveling circus, then Dr. Pelet (who is an extremely conscientious physician) would not have given you nitroglycerine tablets to take, and you would not consequently have suffered from internal explosions, burnings, and mild indigestion. That will teach you to bluff your way through life, dear boy.[2]

With Allais's book in hand, Duchamp could conveniently grab a moment of private hilarity here and there throughout the day.

Before heading home to enjoy a rare social afternoon and evening, Duchamp had a final errand to run. He made it to the post office before closing to mail two letters. One is an encouraging note to Jason Harvey, the brother of an inventive but under-recognized artist, Anne Harvey, who had died the previous year. Before outlining his upcoming travel plans, with instructions for a planned discussion, Duchamp wrote, "Dear Jason, I will be glad to help find a good gallery for Annie's work." Duchamp's written words convey his openness and generosity.

The second message, written two days before, assumes a darker tone. Four months earlier, he had written to Pierre Belfond, publisher of the collection of interviews by art historian Pierre Cabanne, *Entretiens avec Marcel Duchamp*, asking for his share of the royalties from Viking Press for its English translation. Now he wrote: "You have ignored my letter and I repeat here, one last time, my fervent hope that this is just a misunderstanding."[3] It was indeed a misunderstanding—on Duchamp's part. He had either forgotten or never known that his wife's lawyer had received and cashed the check long before. Dispatching this letter must have cast a fleeting shadow over the afternoon.

But the remainder of the day beckoned. Georges Herbiet, a poet who had gone by the name "Christian" since the glory days of Dada, would visit in the late afternoon. In the evening, the photographer Man Ray, the writer Robert Lebel, and their wives would join Duchamp and Teeny for dinner at their apartment.

About an hour after Duchamp returned home from the bookshop, Herbiet arrived. He and Duchamp had started seeing more of each other in recent years, drawn closer by the loss of mutual friends and the knowledge that soon enough their time would come. During the visit, they discussed the miseries of old age. Duchamp said he had suffered from "la grippe," a bad cold, several weeks earlier while vacationing with Teeny in Cadaqués. A Spanish doctor's prescription had made him feel better: "The doctor prescribed I don't know what suppositories.

I took two, and after a while my head started to sweat and felt as if it would burst. I became delirious and I had some very wild visions. I wasn't able to take the third dose as the doctor had ordered. After that, I felt just fine. But tell me, do you also sometimes suffer from these stabbing pains between your ribs? … Yes, that's it, the pains right here, very sharp." Duchamp rubbed his side with his left hand, near his heart. Herbiet said he experienced aches and pains unpredictably in any part of his body and relieved them with aspirin. "With me, it's always here," Duchamp said, putting his hand over his heart. Then they went on to talk of other things.

The conversation turned to Herbiet's late wife, whom Duchamp had last seen in May, on the eve of her death. He was curious about her last moments. But Herbiet didn't have much to say. It was very peaceful. She had "given up the ghost" a quarter of an hour before he even noticed. "It is a death to be wished for," said Duchamp. "It's strange," Herbiet replied. "We don't know when or how the spirit enters us, and we don't know when it departs." Perhaps, he mused, someone should invent a machine to capture all those spirits. Duchamp picked up the thread. "Ah, that's H. G. Wells," he said. "But along those lines, it's curious that ideas coming from living minds maintain a feeling of permanent reality after death. We know the thoughts and words of Socrates and Plato, for example, and we can almost see them chattering away as if they were eternal." Later, Herbiet would recall that Duchamp seemed to be dreaming as he spoke.

They talked about old times, of when and where a mutual friend was first encountered, of artist friends, both old and young, in Paris and New York. Duchamp said he planned to travel to Chicago soon for the opening of a major Dada and surrealism exhibition. After that, he wouldn't budge. He would not read or write. He would spend an hour here and there in conversation only if it led down untrodden paths. "But what would please me most now," he said, "is to live as much as possible sitting down, giving myself chess problems to solve mentally. I make drawings to help me arrive at solutions. But for all practical purposes, I don't play chess anymore. Two or three hours of concentration, it's too fatiguing."

A young artist whom Duchamp was fond of was trying to convince him to go to Cuba. He wanted to bring together Fidel Castro and the grand old master of intellectual anarchy. He wanted to talk politics, find out where Duchamp stood. This was 1968. There had been the student riots in Paris in May, followed by upheavals at the Democratic National Convention in Chicago in late summer. But Duchamp had shrugged off the question. "It's best to respond to all this like Aristippus," he told Herbiet, referring to the student of Socrates who established his own school in 390 BC. Aristippus based his philosophy on two Socratic principles, virtue and happiness. But he emphasized happiness, maintaining that the study of virtue was amusing but useless. The wise man, Aristippus said, must not surrender his liberty to any group or belong to either the governing or governed class. There

is a chronicle, Duchamp continued, that records how the philosopher was chastised by his colleagues for groveling at the feet of a tyrant to ask a favor for a friend. "Well after all, it's not my fault if he has ears on the bottom of his feet," Duchamp quoted. Aristippus would do as he pleased. He'd had a dignified conversation with the tyrant whose reversed anatomy simply meant that he was carrying his bowels in his brain. Aristippus had the last laugh. This made Duchamp laugh, too.

Duchamp told Herbiet about a trip he had taken the previous day to attend the unveiling at Rouen's prefecture of *The Large Horse* (modeled 1914, cast 1966), an enlarged casting of his late brother Raymond Duchamp-Villon's cubist sculpture *The Horse*. Duchamp had grown up in Blainville-Crevon, a village near Rouen, and attended the Lycée Corneille there. Later, he followed his older brothers to Paris, and his parents and his sisters moved to Rouen. The strength of family ties was the secret of Duchamp's own strength. In his early years, he rode the train back and forth between Paris and Rouen, eighty miles each way, as if it were a mantra. He made a self-portrait imagined from one of those rides, a vibrating jumble of moving limbs in a moving train titled *Nude (Study), Sad Young Man on a Train* (1911–1912). The work is a meditation on the loneliness of becoming an independent adult, even in a close family.

By contrast, the previous day's trip had been a joyous occasion. "It was beautiful, a beautiful monument in bronze," Duchamp told Herbiet, adding that the city and state had quickly and easily raised the necessary funds

to erect the monument following the May riots while other business had seemed to grind to a halt. Duchamp had loved and admired his older brother, ten years his senior. Considered the strongest sculptor among the cubists, Raymond had been the first of the six siblings to die, a casualty of the First World War. Now, an important milestone was approaching—the fiftieth anniversary of Raymond's death was six days away. Duchamp had frequently referred to a fifty-year span, which he sometime called "a delay," in considering art and artists as they flowed through history. Fifty years could send a famous work into oblivion or rejuvenate one that had been forgotten. What he couldn't have known was that by early the next day he would have completed an important delay of his own.

When it was time for Herbiet to take his leave, Duchamp walked his friend to the hall. They stood facing each other before the open elevator. Each laid a hand gently on the other's shoulder. They engaged in a deep embrace, something that had never happened before. The next thing he knew, Herbiet was watching his friend wave farewell through the grill as the elevator descended.

1 Marcel Duchamp, *Marcel Duchamp, Notes*, ed. and trans. Paul Matisse (Paris: Centre national d'art et de culture Georges Pompidou, 1980), note 168.

2 Alphonse Allais, *The World of Alphonse Allais*, ed. and trans. Miles Kington (London: Faber & Faber, 2008), p. 131.

3 The letter to Jason Harvey is discussed in the auction-catalogue entry on lot 69 of the Fabulous Autographs and Art, from Van Gogh to Hendrix, University Archives, September 19, 2021. The letter to Pierre Belfond is discussed in the auction-catalogue entry on lot 57 of the Pierre and Franca Belfond Collection, Artcurial, Paris, March 26, 2013. The postmark on both letters records the date as "01 x [October] 69."

In 1949, Duchamp wrote to his brother Jacques Villon from an art conference in San Francisco. "I found myself, for the first time in my life, in front of a microphone and in a foreign language to boot. You can imagine what gibberish, no matter." By 1963, when Duchamp entered into what he called his "sex maniac" phase, he had mastered public media. He was ready to "be raped and to rape everyone." What he meant was that he would give TV interviews, answer questions, go to an occasional opening or Happening, and be filmed by Andy Warhol. He had some explaining to do, and not only about the work he had already made. He wanted to stretch people's notions about what art could be. Calvin Tomkins, the author of Duchamp's definitive biography, first interviewed him for *Newsweek* in 1959. The young reporter, who asked the artist how he was spending his time, came away from that meeting with a scoop: "I am a *respirateur*—a breather. I enjoy it tremendously." Duchamp, it turns out, had been working on this project for at least five years. He had told a French journalist in 1954: "An individual can do something other than the same profession from the age of twenty to his death. I expanded the way of breathing." *The New Yorker* filed its report about breath and art in 1957; *Time*, in 1965. A year later, interviewed by Pierre Cabanne, Duchamp said, "I like living, breathing, better than working ... my art would be that of living; each second, each breath is a work which is inscribed nowhere,

which is neither visual nor cerebral. It's a sort of constant euphoria." Just as through the simple act of choosing he had turned a urinal into the sculpture *Fountain* in 1917, and through a demanding, five-decade process made it stick, Duchamp now switched from inanimate objects to the animated human body—his own—as the realm in which to challenge the definition of art.

Fountain had enraged almost everyone. It had been tossed into the dark slot between two partitions at the 1917 exhibition of the Society of Independent Artists in New York. It might have disappeared for good were it not for a photograph taken by Alfred Stieglitz. To resuscitate it twenty years later, Duchamp sculpted a scale urinal out of papier-mâché and varnish, slightly more than two inches tall and a stunning feat of miniaturization. It was the model for three hundred in glazed porcelain to be included in an edition of suitcase-size boxes—museums in miniature of his complete works. With the circulation of the miniatures, *Fountain* gained momentum. In 1942, the tiny original model was purchased by Duchamp's friend Henri-Pierre Roché. By then, the varnish had darkened and the edges were curling. "It's a little masterpiece of humorous sculpture, the color of boiled shrimp," Roché wrote in his diary.

By the sixties, when Duchamp was well into his "sex maniac" phase, *Fountain* was coming on strong in the form of life-size surrogates displayed in galleries and museums, thrilling and infuriating several million times more art lovers than at its first appearance. When it came

time for an interview with *Vogue* in 1963, on the occasion of the fiftieth anniversary of the 1913 Armory Show, Duchamp was lying in wait for William Seitz, the interviewer and a curator at The Museum of Modern Art in New York. He would be polite but insistent as he upped the ante. "What's happened to art since 1913?" was promoted on *Vogue*'s cover beneath bolder teasers such as "Day Clothes Whizzed with Charm" and "The Oliver Haircut." Seitz wanted to talk about the uproar Duchamp's painting *Nude Descending a Staircase* had caused at the Armory Show. It had upset everyone, including Duchamp's artist brothers. "Even their little revolutionary temple couldn't understand that a nude could be *descending* the stairs," Duchamp said, referring to the cubists. Seitz asked how Duchamp would describe his own revolutionary activity. Was it "aesthetic" or "philosophical?" "No, no," Duchamp replied. "Not even metaphysical. In the end it comes down to doubting 'to be.' ... There won't be any difference between when I'm dead and now, because I won't know it. You see the famous 'to be' is consciousness, and when you sleep you 'are' no more." Duchamp was pushing to the limit: "Language and thinking are the great enemies of man, if man exists. And even if he doesn't exist ..." Seitz interrupted here, steering the conversation back to the painting, something for the *Vogue* reader to hang onto until reaching the next article, "What's Fragile Skin ... What Isn't."

That evening, Duchamp's oldest and dearest friends, Robert Lebel and Man Ray, accompanied by their wives, arrived for dinner. Lebel had published the first monograph about Duchamp, almost a decade earlier, bringing his work into focus for a generation of artists in New York. Man Ray, contributor to both the surrealist and Dada movements, had collaborated with Duchamp on a wide range of projects and was by now considered a grand old master of photography. They were a pair: Man Ray, wiry, grumpy, his brow gnarled, always ready with his skills as a photographer to help Duchamp bring an idea to life; Lebel, well fed and jovial, beneath the surface a bit too serious and hungry, the kind of biographer Duchamp required. The Lebels arrived after Man Ray and his wife, Juliet, and found Duchamp sitting in his armchair. Lebel noticed that Duchamp looked pale, and for an instant his imagination drifted. He saw old paintings, a vision of Socrates sitting on his prison bed, the cup of hemlock in his hand. This made a forceful impression. But when Duchamp rose to greet his guests, the vision quickly passed. Duchamp seemed as healthy and lively as a young man. The spell was broken. Still, out of the corner of his eye, Lebel caught a glimmer of anxiety in Teeny's face.

The friends got down to the business of enjoying each other's company. Man Ray passed around a photograph, a close-up of Duchamp's lap taken at his eighty-first

birthday party that summer in Cadaqués. The artist's hands, relaxed, as if they had just executed a clever chess move, frame the edges of a large, icing-smeared doily holding the remains of the birthday cake. Ten candles teeter like phalluses. A fly is about to eat a crumb.

A dinner of pheasant was served, and Duchamp, famous for eating virtually nothing, picked at it. Everyone except Man Ray, famous for scowling, beamed all the way through the meal. The only interruption was brief: Duchamp was jolted by a spasm but quickly recovered, dismissing the incident as a passing chill. Afterward, an air of high cheer settled in. Duchamp reached for his new edition of Alphonse Allais, stories he said filled him with jubilation. Allais had invented a word, "anthumous," a subtitle for the volume that toyed with literary convention. The word indicated that the book had been published while the author was still alive. "These are only the anthumous works," Duchamp said, "the posthumous works will follow, *but who will publish the others?*" Lebel later put these words in italics in his account of the evening. He was startled. The "*others*" were works published neither before nor after, but at the moment of death itself. This was all Lebel could imagine.

During interviews, Duchamp had spoken of death as a blip, the sudden end of an illusion, something occurring too quickly to comprehend. Writing on a scrap of paper he had recorded a description of the tiniest segment of time he could imagine:

Infrathin separation between
the detonation noise of a gun
(very close) and the apparition of the bullet
hole in the target—
(maximum distance
3 to 4 meters—Shooting gallery at a fair).[4]

What Lebel saw made him uneasy. Duchamp was in the process of disappearing and was enjoying his passage tremendously. Right before his eyes, the painter of *The Passage from Virgin to Bride* (1912) was being deflowered by mortality and loving it. Later, the friend would recall how Duchamp burst out laughing when a round of wordplay began, French to English, punning on the word "tomb." Duchamp had called out to his friends to witness his delight in toying with a somber word, as if ordering them to notarize it. But by now the burden of overwhelming good cheer was too much for Man Ray. He continued the play with Duchamp's painting titles, turning to his first study of the idea of movement. "You are sad, you have always been, since you already were the Sad Young Man on a Train," Man Ray said.

At a quarter past midnight, Duchamp accompanied his friends into the hall. Lebel was deeply unsettled. It was not the first time he had drawn conclusions about Duchamp that had proven wrong. He yearned for this to be true again as they stood together on the landing. No one summoned the elevator. Duchamp looked at his friends for a long time, not speaking.

When they finally reached the street and were walking toward Lebel's car, Man Ray slipped and fell. The others rushed to help him, but he was unhurt and unfazed. "You'd thought I'd dropped dead," he said in English. The phrase struck a nerve, and the hilarity returned. On the ride home, the friends improvised a melody with variations on the theme. "Drop dead! Drop dead!"

After their guests had left, Duchamp and Teeny sat together in the living room, enjoying a few more Allais stories, which Duchamp read aloud. The cabaret humorist had certainly delivered that day. Then, it was time for bed. But Duchamp was taking longer than usual in the bathroom, so Teeny went to check. She found him lying on the floor and knew right away that he was dead. It was 1 a.m. Duchamp's nephew, a physician, was called. Then, Teeny phoned Man Ray, who arrived an hour later to pay his last respects and photograph his lifelong friend and collaborator on his deathbed.

Duchamp had previously hinted that his goal as an artist was to vaporize the universe as if it had been an amazing dream. Now, his collaborator Man Ray was choosing an intimate vantage point for the final portrait, close and on his knees. In the photograph, the side of Duchamp's face is in shadow, but bright light, coming in from above and behind, pools below his eyes and catches the edge of his profile. While Duchamp had been gaunt in old age, in this picture, his cheeks are round and full (due to the slackening of muscles that occurs soon after death). His freckles stand out against the pallor of his skin.

The cause of Duchamp's death is unknown. His *New York Times* obituary reported that he "collapsed after having dinner with his wife and some friends." Dr. Jeffrey Berman, a pulmonary specialist from Boston, agreed to perform a "forensic historical autopsy" in the absence of a physical autopsy. Berman concluded that the most probable cause of death was a "catastrophic" case of pleurisy. "The mention of chills is interesting, and leads me to the hypothesis that the untreated infection in the chest occurring at the time of his 'grippe' might have been, in fact, pneumonia, with infection spreading to the space surrounding his lungs. This might have festered in a low-grade manner, causing ongoing chest pain. His death in this situation would have resulted from pleurisy, a sudden and rapid accumulation of fluid around his heart. This could have led to his gentle and final slump to the bathroom floor."

Man Ray saw the case differently, departing from the realm of physiological possibility and turning to the metaphor of an artist always in command. He wrote in a commemorative issue of *Art in America* dedicated to Duchamp in 1969:

On October 1st about midnight Marcel
closed his eyes and passed away
With a little smile on his lips
His heart had obeyed him and had
ceased beating
As formerly his work stopped

Ah yes it is tragic as an endgame
in chess

I shall not tell you any more.

Man Ray's photograph of Duchamp on his deathbed, made public for the first time with this story, was acquired by the Getty Research Institute in Los Angeles at the end of 2011. Executed as quietly as a breath, it had survived the long delay. Had the master chess player done it again? Could Duchamp's death have been a time-bound readymade "at such and such an hour," as the artist had scribbled half a century before, "a kind of rendezvous?"

This "rendezvous" might be thought of as a collaborative performance that explores the passage from one state to another, with Man Ray as photographer and Duchamp as subject. The two had done it before. In Man Ray's photograph *Rrose Sélavy* (c. 1920–1921), Duchamp appears as a woman, a gender switch that depends on gesture, clothing, and makeup. There was a long period of obscurity following the creation of Rrose, similar to that of *Fountain*, but her charm was ultimately irresistible. She blossomed in 1997, in a major exhibition at the Solomon R. Guggenheim Museum in New York, *A Rrose is a Rrose is a Rrose*, a survey of gender, photography, and performance balanced on the fulcrum of her image.

A work of art needs a title. In his later years, Duchamp carried in the inner pocket of his coat a scrap of paper scribbled with the phrase "Besides, it is always the oth-

ers who die." This became his epitaph, carved above his name on the family gravestone in Rouen. Use this as a title for Man Ray's photograph, and what do you have? A final collaboration? A Dadaist provocation? Duchamp carefully established breathing, his own breathing, as a form of artistic expression. Is his last breath a variation on this theme? It is impossible for someone who is alive to imagine being dead. Look at Man Ray's photograph of Duchamp on his deathbed and try to slip this thought into the mind of the deceased: "It is always the others who die." It can't be done.

4 *Marcel Duchamp, Notes*, note 12.

Art presents itself. It wants to be seen. If Man Ray's photograph of Marcel Duchamp on his deathbed is a work of art, it will be exhibited, reproduced, and evaluated. It will enter the public realm as an object expressing desires, questions, doubts, and certainties. If it is not art, it returns to the archive as a document to be consulted by scholars.

"But is it art?" is the question Duchamp devoted his life to asking. By the end, he had brought the art world with him, teetering on the brink of acceptance, and after his death, a wholehearted embrace, of the answer he had determined from the beginning: anything can be art that is seen and treated as art. Not necessarily good or bad, but art just the same. So now we are stalled at Man Ray's photograph. If anything can be art, why don't we remove a label from the conceptual roll and stick it on this image of the deceased man lying here, who gave us the very freedom to do so?

Art is anything the artist makes or chooses.

Weaving life and death together, or merging one with the other by imagination, artistry, and sleight of hand, is an undercurrent that flows, often unnoticed, throughout Man Ray's work. He was fascinated with life and death masks, solid sculptures cast from plaster molds made directly from the heads of breathing or still subjects. Man Ray himself posed for portraits many times with his own

life mask or a variety of papier-mâché carnival masks, positioning them against his cheek and enacting a comedy.

In 1929, Man Ray photographed Amedeo Modigliani's death mask, which is quite well known. The mask is the only postmortem image of a twentieth-century artist to appear often on public display as an art object. Small and withered, it could fit in the palm of your hand. It marks a sad moment, the early death of an artist on the brink of public recognition.

In 2014, the Smart Museum of Art in Chicago mounted the exhibition *Carved, Cast, Crumpled: Sculpture All Ways*, which included Modigliani's plaster death mask—isolated, in a Plexiglas case, illuminated by a single, sharp light. The effect was mind-numbing, like the frigidity of outer space. A bit of illumination reflected off of the chin and back into the mouth's shadow. It seemed that Modigliani wanted to speak, to beg, at last, for utter disappearance. But he remained, as the show's title dictated, a thing, a small plaster object, a sculpture.

In his photograph from 1929, Man Ray determined to bring Modigliani peace, but to do so he had to counter his disdain for the darkness of the void. "Blacks give no more strength to a photograph than 'strong' drink gives strength to a man," he said. He almost always stuck to it, except in this image, which evokes the blacks of a moonless night. He wrapped them gently around Modigliani's cheek and forehead, allowing him to rest with the knowledge—infinitesimal in the scheme of things—that his work would outlive him.

Man Ray produced one more image called *Death Mask of Modigliani* (1927). It is an illusion made using his favorite of the half-dozen papier-mâché theatrical types—a generic Modigliani look-alike. The line defining the mask's profile appears to be the result of the artist's recent discovery that flashing a light briefly during the developing process can produce an uncanny darkened edge between foreground and background. But Man Ray, a master of invention in the darkroom, seems to have gone further. The line takes off as if it were drawn by hand. It enters the shadows to define the nostril and hollows out the forehead, turning a relic of death into a lively dramatic mask. More darkroom magic trims the bottom of Modigliani's jaw. He now appears ready to take his next breath.

Here is an interchange between two artists, one living, one dead. But Man Ray certainly did not collaborate with Modigliani. The painter is not in any way coauthor of this photograph. Is the deathbed image of Duchamp different? Can the lifetime collaboration of two artists be extended a few hours after one of them has died?

Yes, if both artists took part in the process that led to the photograph. The "anything" of art must have a specific human maker. A collaboration needs two. Duchamp would agree. When writer Katherine Kuh asked him about authorship in 1961, for her book *The Artist's Voice*, Duchamp replied: "I don't want anonymous art.... I still believe in individualism in art." In a manifesto-like talk in 1957, he characterized the artist's process in relation to the crucial role of the spectator as "a series of efforts,

pains, satisfactions, refusals, decisions." This is very far from a passive, hands-off position. Paul B. Franklin, formerly of the Association Marcel Duchamp, which manages the artist's estate, was justified in his concerns when he questioned "whether the archival record offers any insights into the reasons or negotiations surrounding the creation of this photograph. For instance, do we have any testimonies, even if relayed via a third party, from Man Ray or Teeny Duchamp regarding the photograph?"[5]

The search for a documented contract is imperative.

At the end of his short statement in the Duchamp memorial issue of *Art in America*, Man Ray says, after evoking the last evening, "I shall not tell you any more." Does anyone say this unless there *is* more to tell? Here, could the untold be the existence of the photograph, and the process of making it, taking up the late night and early morning after the final dinner?

Man Ray rendered the death of Duchamp as a film scene, as if a camera were rolling and recording stillness. His photograph disappeared immediately after its creation and remained completely unknown until its acquisition from the Combe-Martin estate by the Getty Research Institute. Man Ray was famously fastidious in the cataloguing and maintenance of his life's work. Yet there is no sign of his postmortem portrait of Duchamp in the Centre Pompidou's massive collection of his work in Paris or in catalogues of large auctions from his estate. Man Ray seems to have preserved this single photograph while

deliberately withholding it from view, far away from his studio. It is not known when it was acquired by Michael and Elsa Combe-Martin, who assembled their collection from their close friends, the artist and his wife. But an inscribed wooden cigar box among the materials sold to the Getty in 2011 provides a clue. Man Ray made a handful of works out of cigar boxes, in a few cases inserting an eyepiece, suggesting a dark secret inside. The Combe-Martin box serves as a container for a thin sheet of wood on which is written a New Year's greeting from Juliet and himself dated 1969. Beside the inscription, an exuberant penciled bird flies upward, like a Phoenix, toward a five-pointed star. The box would have been cumbersome to send in the mail as if it were a card, and it most likely would not have arrived before the new year. Probably the friends got together exactly three months after Duchamp's death. The understanding and support of Michael and Elsa must have helped Man Ray to face the first new year without his longtime companion and laughing partner. The box is a tribute to friends who could be entrusted with Man Ray's only print of the final photograph. It would leave his possession. But its significance as a document, if not a work of art, compelled him to preserve it in the hands of Michael and Elsa, who would pass it on to their heirs, and then to a public institution at an unknown time.

Now, we must examine Duchamp's role in the postmortem project. When the physiological death process is underway, people can experience a psychological sense of detachment, sometimes with great lucidity. Duchamp's

constant chest pain, as described to Georges Herbiet earlier that day ("For me, it is always here"), and his case of the chills at dinner suggest a chain of events leading to heart failure. A feeling of pending departure is thought to be largely subconscious. Duchamp couldn't have known that death was imminent, but he felt both delight and sorrow that evening with his wife and closest friends. And, as always, he was quietly exhilarated at the hint of a new venture into the unknown. This is how Lebel saw it:

> It was … a longing for total liberation that he conveyed to Man Ray and me during the evening of October 1, 1968.[6]

But is it art?

Where is the record of an agreement among Teeny, Man Ray, and Duchamp that the photograph should be taken, or that some kind of object should be made or chosen to embody Duchamp's passage from life to death, just as *Rrose Sélavy* embodies Duchamp's imagined passage between sexes? The original photographic prints depicting Rrose, extremely valuable works of art, bear the signatures of both artists.

The file of notarized documents has been examined. It is empty. No identification of the subject is inscribed on the postmortem portrait. Nor is it mentioned in the accompanying archival materials acquired by the Getty. But there is one document to consult as a record of the spoken words of Duchamp, Man Ray, and Lebel: the

succinct report of Lebel's thoughts preserved in his essay "Last Evening with Marcel Duchamp," from 1968. In what follows, events are arranged chronologically, with direct quotations from the document.

EVENT #1—After dinner, with Teeny and all the guests gathered around, Duchamp "leafed through a volume of a new edition of Alphonse Allais's works in front of him, which, he told us, filled him with jubilation. 'These are only the anthumous works,' he specified, 'the posthumous works will follow, *but who will publish the others?*'"

EVENT #2—Lebel reports his response: "I announced at once my intention of writing another book about him that would clearly distinguish between his *an-Tu m'* and *post-Tu m'* periods …" Lebel had worked for six years on the first book ever written about Duchamp, who handled all of the graphic design. Both men struggled, often battling with the publisher, to ensure that a clear English translation would appear in the crucial American edition. It was a long and difficult process. But they stuck with it, and the results were, in the long run, monumental. For Lebel, the leading expert on book collaboration with Duchamp, the question "*but who will publish the others?*" served as a catalyst for a second book concept. This one would separate the periods before and after Duchamp died, or entered the "tomb." Lebel is punning on the French phrase "tu m'," which sounds like the English word "tomb." *Tu m'* is the title of Duchamp's final painting, from 1918. Lebel turns reflexively to mere wordplay. The painting has no substantive connection with his book idea.

A tantalizing possibility emerges. Is Duchamp's question a plea for another collaboration concerning a physical or metaphysical transition? Lebel has not yet considered the notion, raised by Duchamp's question, that the "*others*" may be works that appear in a gap, possibly outside of linear time, between life and death.

EVENT #3—Teeny and Man Ray, sitting nearby, hear Lebel's announcement, which elicited this retort from Man Ray: "No, you are sad, you have always been, since you already were the Sad Young Man on a Train." Man Ray, the lifelong Duchamp collaborator, picks up on Lebel's play with painting titles without allowing a pun to interfere. Is he, too, considering the creation of a work in response to this electrified moment? Not at this point. He simply and directly identifies Duchamp, from the first time they met, with an earlier painting, *Sad Young Man on a Train.*

With any other group of participants, this conversation, as testimony concerning an artist's involvement in his own postmortem photograph, could be dismissed without further consideration. It is rife with wordplay. But to these three men wordplay was a deadly serious and intimate business, part and parcel of their friendship. Hopelessly addicted, Lebel states elsewhere, "Nothing, alas, when I am with Marcel, can stop me on the dreadful slope of spoonerisms."

EVENT #4—This is a mental event, recounted by the author in the first person. The minds of the participants appear to be intertwined. According to Lebel, the minds

of Duchamp and Man Ray in particular were in immediate and direct contact. Lebel testifies that Man Ray's ability to read Duchamp's mind went far beyond his own. He wrote specifically about this moment twelve years later, "At the home of Duchamp, an hour before his death, I verified that little said, a sign, a grimace, or the wink of an eye sufficed for Man Ray to understand Duchamp completely."[7] The following is a record of a mental event, Lebel's pang of remorse:

> Man Ray's affectionate sharpness made me regret having cut Marcel short in his evocation of an intermediate and magnificent time at the frontier between life and death. I should have finally asked him to develop this notion—surely not a metaphysical one—of "passage," which has intrigued me since his 1912 painting *Le Passage de la Vierge a la Mariee* [*The Passage from Virgin to Bride*].

Lebel concludes with a report, at first confident and definitive, then speculative, of what was playing out in Duchamp's mind:

> What he had just been suggesting in relation to Alphonse Allais proved that he was still thinking about it and perhaps also thought of himself as being in a "transit" situation. But how could I ask him such a direct question, which he would most likely have eluded?

Lebel's narrative takes us to the edge of an abyss. He conveys his personal convictions, but he cannot get himself to ask Duchamp. We can go no further because there exists, in the end, no evidence of a collaborative agreement between Man Ray and Duchamp, nor of the latter's interest in a "'transit' situation," in an "infrathin delay" between life and death. One's own death, from everything he ever said about it, is simply nothingness, a disappearance, the end of the illusion of life. It bears no relationship to *The Passage from Virgin to Bride*, a transformation between two living states.

The death of "*others*" is radically different. Duchamp left vivid evidence in his letters of his pain and grief upon the loss of friends. It is always the others who die.

5 Paul B. Franklin, email message to the author, April 11, 2014.
6 Robert Lebel, "Portrait of Marcel Duchamp as a Dropout," *Étant donné Marcel Duchamp*, no. 7 (2006), p. 82.
7 Robert Lebel, "Man Ray et Duchamp avant et après," *Journal Artcurial* (May 1980), p. 2.

When Teeny telephoned Man Ray in the early morning of October 2, 1968, Man Ray seems to have made his decision on the spot. He would leave immediately but not before he grabbed his tools—a tripod, for a long exposure in meager light, a camera, and a striped, dark cloth that appears as a backdrop in other photographs. A mirror was also needed, but Teeny could provide that.

Duchamp was laid out on his bed in the top-floor apartment in Neuilly-sur-Seine, parallel to tall sloping windows facing east. The sun would soon rise to provide the graphic and emotional core of the image—the gentle flow of morning light that defines his profile and caresses his closed eye, a keen eye that saw beyond the "retinal" in a rich dialogue with the mind that lay behind it. The mind had completed its task. Teeny said she found Marcel with a pleased expression on his face.

Man Ray and Teeny seem to have considered Duchamp to be finely dressed just as he was. The only thing missing was a necktie, which he certainly wouldn't have worn as he prepared for bed. Whenever Duchamp had donned a tie, even an outmoded one, he had been the most stylish man in the room. Apparently, someone gently wrapped Duchamp's "best" tie around his neck, now growing cold. A knot was uncalled for. The tie became, most probably in Man Ray's improvising hands, like a defining form made with a paintbrush. One end drapes toward the viewer and delineates the lower edge of Du-

champ's jaw. It makes of his head a fine memorial sculpture, ever simplifying, a Brancusi in process. The other end is a free stroke. It floats in the air parallel to the collar line below, a poetic hint of dematerialization.

Nadar, the first great portrait photographer, produced a postmortem image of Victor Hugo, whose death on May 22, 1885, brought Paris to a halt for three days. The morning sun from the east etched Hugo's profile against a dark ground, just as in Duchamp's portrait, but the image otherwise departs from the fine edges that Man Ray sought. The light got tangled in the writer's beard, creating a halo that seems to confirm he was a great man. Nadar had attached a dark curtain to the lower half of a window parallel to the bed. Light flowed in from a place above the upper edge of the photograph. An assistant, slightly to the side and in front of the subject—just out of the frame—held a mirror to reflect window light back onto Hugo's face, bringing out detail and preventing a featureless shadow.

A drawing by Nadar, owned by the J. Paul Getty Museum in Los Angeles, illustrates the scenario in Victor Hugo's bedroom precisely. Such a detailed and intimate drawing by hand of a photographer's setup is extremely rare. Of course, Man Ray never saw this drawing, though he attached his black curtain in the same position. He was improvising, as he always did. Teeny may have aimed the mirror.

*

After Duchamp's death, Man Ray yearned to keep his friend's joy and elegance in play. He needed to stay in touch. The postmortem image of his own making must have painfully denied this possibility, so he used his improvisatory skills to create a mixed-media object featuring a small photograph that conveys in an instant the dynamics of their friendship. It shows them very much alive and in the midst of rummaging through old clippings. Duchamp points to an unseen graphic on a torn sheet of paper, as if delivering a punch line. He and Man Ray are lost in an easy boisterousness that does not blossom with such clarity in any other image. The photograph, curled at the edges, was attached with apparent carelessness by a postage stamp to the outside of a small standing frame, then placed on the back of the couch in the dead center of Man Ray's final Paris studio. This photo-sculptural keepsake appeared over and over—in three books that document 2 bis rue Férou and in portraits by several photographers of Man Ray, Juliet, and their friends. Without claiming to be art, it quietly occupied the physical and emotional center of their world.

Although it wasn't revealed for a decade, Henri Cartier-Bresson, a friend of Duchamp and Man Ray, made the photograph. He was a founder of Magnum, the collective organization dedicated to protecting photographers' authorial rights. Almost certainly, Teeny, Juliet, and Cartier-Bresson made a pact. For a time, the image that preserved the conspiratorial laughter of the artists would take the guise of an anonymous snapshot res-

cued from the breeze on a sidewalk.[8] Only a found object, or one presented as found, like a readymade, could fill the "absence of an absence," and counter the memory of the postmortem image, which turned out to be so painful for Man Ray that, without destroying it, he made it disappear.

Does an artist, especially one like Man Ray, who edited and controlled everything, have the right to banish one of his works from the realm of art? Yes, he does. Art presents itself. It wants to be seen. If an object remains in darkness, removed by its maker, absent from the world and the "art world," it is not art.

8 The image first appeared in 1988—a picture within a picture, giving a
 feel for its homey, couch-top setting—as the full-page frontispiece to
 Neil Baldwin's definitive biography of Man Ray. The still-life photograph
 by Ira Nowinski (which is cropped in the biography) includes a sculpture
 by Man Ray of a hammer in a bottle, with a bookshelf in the background.
 The image of Duchamp and Man Ray is unattributed. Baldwin refers to
 it in his text as an anonymous "documentary snapshot." He produced
 his book in close consultation with Man Ray's wife, Juliet, and published
 two editions.
 Conspiratorial Laughter, a 1995 exhibition of works and documents at
 the Zabriskie Gallery in New York, traced the working partnership of
 Duchamp and Man Ray. The catalogue, which acknowledges Teeny as
 its living inspiration, includes the photograph of Duchamp and Man
 Ray, attributing it to "anonymous."
 Recently, Magnum Photos posted the image on the internet along
 with several others from the extensive photography session at Man Ray's
 rue Férou studio in the spring of 1968, this time correctly identifying
 Cartier-Bresson as the photographer. For one shot, he moved back a few
 feet and apparently stood on a chair to get a higher and wider view of
 the artists and their wives seated around a table and relishing each
 other's company. This may have been their last gathering before the
 penultimate party, the celebration of Duchamp's eighty-first birthday
 at the end of July in Cadaqués, to be followed by a last evening together
 two months later.

Marcel Duchamp left just one thing undone when he died: he hadn't paid for the bricks. A rough-hewn wooden door, closed for all time and surrounded by a framework of bricks, is all you see upon entering the small, unlit gallery of *Étant donnés* (1946–1966) at the Philadelphia Museum of Art—before you stick your nose up to the door to peek through two small holes. Duchamp selected these bricks, one by one, at a masonry yard in Cadaqués during the summer of 1968 but had not yet made arrangements for payment and shipment. Everything else was complete, from the life-size nude mannequin whose widely spread legs reach out to greet the viewer, to the bed of twigs she reclines on, held in place from below and behind by a square of bent chicken wire. All the parts of this "sculpture-construction," as Duchamp called it—its woodland backdrop and complex lighting, everything that is now behind the door in the museum—had been photographed and moved to a small studio on East Eleventh Street in New York that was, in effect, a temporary holding locker. After the move, Duchamp had all the components, and intertwined groupings of components, rephotographed from every angle. He prepared a second, expanded draft of his assembly manual, and made plans to be in Philadelphia to begin the installation. A letter from March 2, 1968, sent by Duchamp to the lawyer handling this complex transaction, reads: "Without any definite date we may expect

that the transfer of the piece to Philadelphia could not be before next November after our return from Europe." According to his datebook, he came to look forward to an earlier move. On the page of plans for October 18, he wrote an abbreviated, slightly tentative note: "Phila? in the morning." On the following day's page appears "Budworth," the name of his shipping agent, and a sketch of a brick. But they had not yet been shipped when he died. He hadn't paid for them.[9] He may have intended to do so on October 3, the day after his death.

Soon after Duchamp died, his stepson Paul Matisse (Teeny's son) took on the crucial role of engineer in the transfer of *Étant donnés* from New York to Philadelphia. The move was carried out in complete secrecy from the public. On February 19, 1969, a day after the crates arrived at the museum, they were unpacked in a gallery close to their final destination. The sculptural environment was partially assembled by Matisse and Anne d'Harnoncourt, a young curator, then covered and tightly sealed in sheets of plastic. The nearby designated installation space, which used to house Wassily Kandinsky's paintings, had become a dust-generating construction site. The doorway was arrested in a raw state. The Spanish bricks had, by then, been paid for but not yet shipped.

A dock strike, severely overbooked airfreight schedules, and an incorrect address for the museum in the paperwork drew the delay on and on. Soon, other problems arose. Even after its unpublicized opening that

summer, *Étant donnés* was meant to be kept at a distance from the media. Photography of its interior, behind the yet uninstalled door, was prohibited. The magazine *Art in America* planned a story about Duchamp's great posthumous work after the quiet opening. The article had to be completed far in advance. They needed an image of *something*. Art critic Cleve Gray wrote to the museum's director, Evan Turner: "Since we are giving it a full color page, I would like to have the advantage of the effect the reddish bricks make against the grey door." That request was impossible to fulfill. The bricks did not arrive by the magazine's extended deadline.

The delay tormented the already distraught author of Duchamp's upcoming catalogue raisonné, Arturo Schwarz. He was shocked and heartbroken when Teeny wrote to him about *Étant donnés*. He knew nothing about it. Why had he been kept in the dark by the artist he had devoted his life to? A complete draft of Schwarz's supposedly definitive catalogue, in three languages, was due at the printers in early April 1969. Could he at least *see* the work before his deadline and quickly produce a written entry? The delinquent bricks prevented this.

When they finally arrived, on April 11, joy at the museum was barely contained. "The bricks are here," d'Harnoncourt wrote, "and everyone—the museum, Madame Duchamp—is delighted." The creative engineering of Paul Matisse averted a final disaster. Twenty-eight of the 149 bricks had been broken in transit. His delicate and precise drawing, preserved in the museum's archives, shows

how he completed the job with far less material than expected. The bricks surround the doorway with their long rather than narrow sides facing the viewer. Every other row is made of two half bricks. With this new configuration, there were enough bricks. The museum, and soon all of its visitors, could finally focus on the inner space of *Étant donnés*, behind the peepholes in the door.

Duchamp, as others might imagine him, could finally rest in peace.

9 The story of the missing bricks is drawn from Michael R. Taylor, *Marcel Duchamp: Étant donnés* (New Haven: Yale University Press, 2009), chapters 2 and 3.

A note, published posthumously, reads:

> Attach a camera to the stomach, and walk in the
> street, turning the handle.[10]

This protoconceptual work by Duchamp can be dated to
the 1920s based on the time frame of the hand-cranked
camera. Its materials consist of pencil marks on a torn
half sheet of rectangular paper and an image in the
viewer's mind of someone, anyone, performing this ac-
tion or viewing its result. "I am extremely playful . . . and I
believe it's the only form of fun possible in a world which
isn't always much fun," said Duchamp in 1966. It would
be fun to walk in the street vicariously using the latest
image-reproduction technology, as he suggested. In the
year 2018, as of this writing, you can open Google Maps,
go anywhere, grab "Pegman"—the tiny yellow man at the
lower right of the screen—and place him on any street,
ready to go and see the sights. Duchamp imagined the
earliest form of Google Street View, and left this paper
scrap to pass his experience forward.

The Italian artists' collective Lu Cafausu produces
works, or "initiatives," that circle around "play" and
"death"—two words that resist each other. Their 2014
book *Besides, It's Always the Others Who Die* was in-
spired by Duchamp and functions at times like one of
his notes. It presents an earnest but rambling group dis-

cussion about death, initiated by the title (Duchamp's epitaph), which leads nowhere on purpose. One Lu Cafausu member, Luca Musacchio, writes of his restlessness on page 17:

> I like walking. I walk; losing time you gain space and *search*.

Here is where Street View comes in. Luca guides us on a walk in Rome, down Via Giovanni Giolitti from Termini Station, which will help us approach death playfully. We walk with Pegman, following Luca's precise narrative, two blocks north of the huge railway station, and come to a small park fronted by a long wooden row of bookshops—a freight train of books, stalled and open for perusal. We can survey the scene, examine the tables, and decide, with Luca, that what we seek might be under one of those piles on the sidewalk. Street View offers fluidity in time, enabling us to pick a date, June 2014, when the pile in front of Luca's favorite dealer appears most promising, most likely to yield some old philosophy books. He writes:

> It's a dense moment.... I manage to find *The Space of Literature* by Maurice Blanchot. Just what I'd been looking for, for months.

We get back on our feet, straighten up the stack to prevent it from toppling, and dust off the book, uncertain

now if we really want it. We skim the book and stop at page 92, cited by Luca:

> Perhaps art demands that one play with death. Perhaps it introduces a game, a bit of play in the situation that no longer allows for tactics or mastery.

Then, we flip to page 100:

> To die well is to die in one's own life, turned towards one's life and away from death ... the good death shows more consideration for the world than regard for the depth of the abyss.

We pay for the book and head on our way.

10 *Marcel Duchamp, Notes*, note 191.

Images

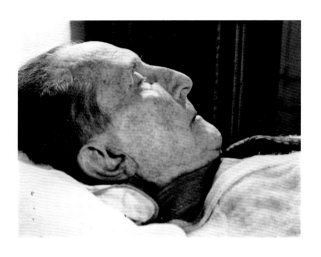

Man Ray, *Marcel Duchamp on His Deathbed*, 1968
Gelatin silver print, 5 ⅛ × 7 inches | 13 × 18 cm

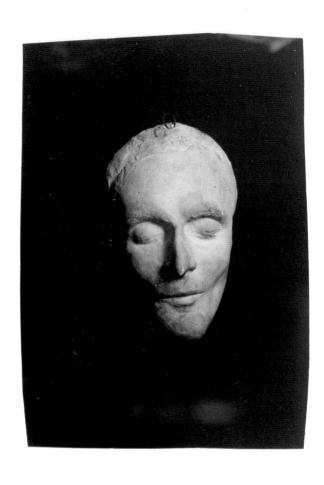

Man Ray, *Deathmask of Amedeo Modigliani*, 1929
Gelatin silver print, 4 ⅛ × 3 inches | 10.5 × 7.6 cm

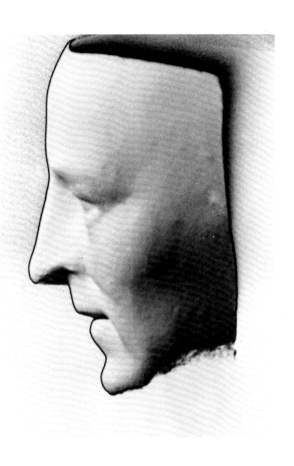

Man Ray, *Death Mask of Modigliani*, 1927
Gelatin silver print, 11 ⅞ × 8 ⅜ inches | 30 × 21.3 cm

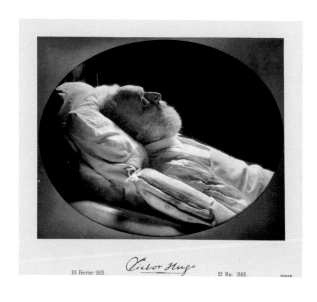

26 Février 1802. *Victor Hugo* 22 Mai 1885. NADAR

Nadar, *Victor Hugo on His Deathbed*, 1885
Woodburytype, 7 ⅜ × 9 ⅝ inches | 18.7 × 24.4 cm

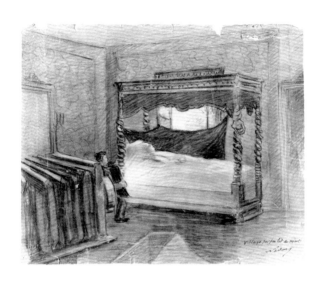

Nadar, *Chambre de V. Hugo*, 1885
Charcoal, 10 ⅛ × 12 ⅜ inches | 25.7 × 31.5 cm

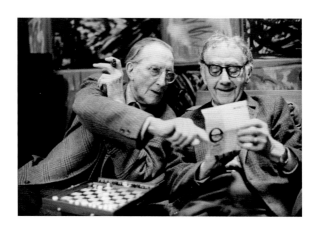

Henri Cartier-Bresson, Marcel Duchamp and Man Ray at
Man Ray's home, 1968
Black-and-white photograph, dimensions unknown

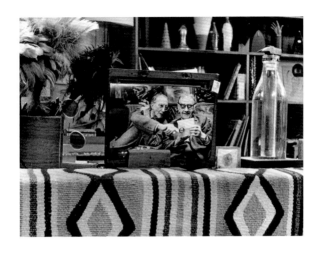

Ira Nowinski, *Photograph of Man Ray's Studio*, 1983
Gelatin silver print, 11 × 14 inches | 27.9 × 35.5 cm

ACKNOWLEDGMENTS

My deepest appreciation to the following for encouragement and guidance on this short book over a period of eight years: Francis M. Naumann, Michael R. Taylor, Carlos Basualdo, and Calvin Tomkins. And thank you, Hattie.

BIBLIOGRAPHIC NOTE

Accounts of Marcel Duchamp's last day: Christian (Georges Herbiet), "Du Champ outre tombe," *Cahiers Dada surrealism*, no. 3 (1969), pp. 8–19; and Robert Lebel, "Dernière soirée avec Marcel Duchamp," *L'Oeil* (November 1968), pp. 19–21. A version with an added final scene: "Dernière soirée avec Marcel Duchamp," in Robert Lebel, *Marcel Duchamp* (1985), pp. 131–134; its English translation, by Monique Fong, is "Last Evening with Marcel Duchamp," with notes and translation of the added final scene by Paul B. Franklin, *Étant donné Marcel Duchamp*, no. 7 (2006), pp. 178–181.

Sources on Marcel Duchamp: Carlos Basualdo and Erica Battle, eds., *Dancing around the Bride: Cage, Cunningham, Johns, Rauschenberg, and Duchamp* (2013); Pierre Cabanne, *Dialogues with Marcel Duchamp* (1971); Marcel Duchamp, *Affectionately, Marcel: The Selected Correspondence of Marcel Duchamp*, ed. Francis M. Naumann and Hector Obalk (2000); Marcel Duchamp, *Marcel Duchamp, Notes*, ed. and trans. Paul Matisse (1980, 1983); Marcel Duchamp, *The Writings of Marcel Duchamp*, ed. Michel Sanouillet and Elmer Peterson (1973); Emilio Fantin, Luigi Negro, Giancarlo Norese, Cesare Pietroiusti, Luigi Presicce, eds., *Besides, It's Always the Others Who Die* (2014); Paul B. Franklin, ed., *The Artist and His Critic Stripped Bare: The Correspondence of Marcel Duchamp and Robert Lebel* (2016); Ann Collins Goodyear and James W. McManus, eds., *Inventing Marcel Duchamp: The Dynamics of Portraiture* (2009); Anne d'Harnoncourt and Kynaston McShine, eds., *Marcel Duchamp* (1973); Pontus Hulten, ed., *Marcel Duchamp: Work and Life* (1993); Richard Kostelanetz, *Conversing with Cage* (1994); Robert Lebel, *Marcel Duchamp* (1959); Man Ray, postmortem statement, *Art in America* (July–August 1969); Herbert Molderings, *Duchamp and the Aesthetics of Chance: Art as Experiment* (2010) and *Marcel Duchamp at the Age of 85: An Icon of Conceptual Photography* (2013); Francis M. Naumann, *Marcel Duchamp: The Art of Making Art in the Age of Mechanical Reproduction* (1999); "Duchamp et après," special issue, *Opus international* (March 1974); William Seitz and Marcel Duchamp, "What's Happened to Art Since 1913?: An Interview with Duchamp," *Vogue* (February 1963); Calvin Tomkins, *Duchamp: A Biography* (1996) and *Marcel Duchamp: The Afternoon Interviews* (2013); and Arturo Schwarz, *The Complete Works of Marcel Duchamp* (1997).

Sources on photography, performance, transition, and death: Simon Baker and Fiontán Moran, eds., *Performing for the Camera* (2016); Gordon Baldwin, *Fame and Photography* (1993); Gordon Baldwin and Judith Keller, *Nadar/Warhol: Paris/NewYork* (1999); Geoffrey Batchen, *Suspending Time: Life—Photography—Death* (2010); Walter Benjamin, *On Photography*, ed. and trans. Esther Leslie (2015); Maurice Blanchot, *The Space of Literature*, trans. Ann Smock (1989); Jennifer Blessing, ed., *Rrose is a Rrose is a Rrose: Gender Perfor-*

mance in Photography (1997); Paul Edwards, "My Death," in *The Encyclopedia of Philosophy*, vol. 5 (1967); Audrey Linkman, *Photography and Death* (2011); Christopher Phillips, ed., *Photography in the Modern Era: European Documents and Critical Writings, 1913–1940* (1989); Susan Sontag, *On Photography* (1977); and "Aristippus," in *Encyclopedia Britannica*, 14th ed. (1929).

Sources on Man Ray: Neil Baldwin, *Man Ray: American Artist* (1988); Emmanuelle de l'Ecotais and Alain Sayag, *Man Ray: Photography and Its Double* (1998); Mason Klein, *Alias Man Ray* (2009); Francis M. Naumann, *Conversion to Modernism: The Early Work of Man Ray* (2003); and Man Ray, *Self Portrait* (1988).

Sources on Marcel Duchamp and Man Ray: Jennifer Mundy, ed., *Duchamp, Man Ray, Picabia* (2008); *Marcel Duchamp/Man Ray: 50 Years of Alchemy* (Sean Kelly Gallery, 2004); and *Conspiratorial Laughter—a Friendship: Man Ray and Duchamp* (Zabriskie Gallery, 1995).

Sources on laughter: Alphonse Allais, *Oeuvres anthumes III* (March 27, 1968) and *The World of Alphonse Allais*, ed. and trans. Miles Kington (2008); and Phillip Cate and Mary Shaw, eds., *The Spirit of Montmartre: Cabarets, Humor, and the Avant-Garde, 1875–1905* (1996).

DONALD SHAMBROOM is a visual artist, writer, curator, and videographer whose work is in the collections of the Museum of Fine Arts, Boston, and The Metropolitan Museum of Art, New York. In 1973, after graduating from Yale University, where he studied philosophy and painting, Shambroom moved to Boston to pursue his career as a painter. Shambroom's interest in Marcel Duchamp began in 1969, when he read Calvin Tomkins's *The World of Marcel Duchamp*. His essays have appeared in *Weltkunst* ("Duchamp's Last Readymade," 2014), *CFile* ("A Urinal Called Fountain," 2017), and *Tout-Fait* ("Marcel Duchamp and Glass," 1999, and "Leonardo's Optics Through the Eyes of Duchamp: A Note on the Small Glass," 2000). He produced *Common Screech Owl, a Millers River Story* (2013), a multimedia natural-history installation, and *The Garnet Cabinet* (2012), a meditation on crystal structure. Shambroom's work has been shown at Francis M. Naumann Fine Art and Half Gallery in New York, and at Howard Yezerski Gallery in Boston. For the past decade, he has lived and worked on the banks of the Millers River in north central Massachusetts.

MARCEL DUCHAMP (1887–1968) was a French American painter, sculptor, chess player, and writer whose work is associated with cubism, conceptual art, and Dada. One of his best-known pieces is a urinal, titled *Fountain* (1917) and signed "R. Mutt," which he submitted to an exhibition of the Society of Independent Artists in New York in 1917. In 1963, on the fiftieth anniversary of his 1913 Armory Show, Duchamp said, "In the end it comes down to doubting 'to be' . . ." Beginning with the original exhibition's *Nude Descending a Staircase, No. 2* (1912), a stationary painting that appeared to move, he proceeded to work patiently, often out of sight, on a fifty-year project to change, then eliminate any stable definition of the manmade concept of "art." Duchamp remains one of the single most influential artists of the twentieth century.

"Ekphrasis" is traditionally defined as the literary representation of a work of visual art. One of the oldest forms of writing, it originated in ancient Greece, where it referred to the practice and skill of presenting artworks through vivid, highly detailed accounts. Today, "ekphrasis" is more openly interpreted as one art form, whether it be writing, visual art, music, or film, that is used to describe another art form, in order to bring to an audience the experiential and visceral impact of the subject.

The *ekphrasis* series from David Zwirner Books is dedicated to publishing rare, out-of-print, and newly commissioned texts as accessible paperback volumes. It is part of David Zwirner Books's ongoing effort to publish new and surprising pieces of writing on visual culture.

OTHER TITLES IN THE *EKPHRASIS* SERIES

On Contemporary Art
César Aira

Something Close to Music
John Ashbery

The Salon of 1846
Charles Baudelaire

My Friend Van Gogh
Émile Bernard

Strange Impressions
Romaine Brooks

A Balthus Notebook
Guy Davenport

That Still Moment
Edwin Denby

Ramblings of a Wannabe Painter
Paul Gauguin

Thrust: A Spasmodic Pictorial History of the Codpiece in Art
Michael Glover

Visions and Ecstasies
H.D.

Mad about Painting
Katsushika Hokusai

Blue
Derek Jarman

Kandinsky: Incarnating Beauty
Alexandre Kojève

Pissing Figures 1280–2014
Jean-Claude Lebensztejn

The Psychology of an Art Writer
Vernon Lee

Degas and His Model
Alice Michel

28 Paradises
Patrick Modiano and
Dominique Zehrfuss

Any Day Now: Toward a Black Aesthetic
Larry Neal

Summoning Pearl Harbor
Alexander Nemerov

Chardin and Rembrandt
Marcel Proust

Letters to a Young Painter
Rainer Maria Rilke

The Cathedral Is Dying
Auguste Rodin

Giotto and His Works in Padua
John Ruskin

Dix Portraits
Gertrude Stein

Photography and Belief
David Levi Strauss

The Critic as Artist
Oscar Wilde

Oh, to Be a Painter!
Virginia Woolf

Two Cities
Cynthia Zarin

Duchamp's Last Day
Donald Shambroom

Published by
David Zwirner Books
520 West 20th Street, 2nd Floor
New York, New York 10011
+ 1 212 727 2070
davidzwirnerbooks.com

Editor: Lucas Zwirner
Project Manager: Mary Huber
Copy Editor: Deirdre O'Dwyer
Proofreader: Michael Ferut

Design: Michael Dyer / Remake
Production Manager: Jules Thomson
Printing: VeronaLibri, Verona

Typeface: Arnhem
Paper: Holmen Book Cream, 80 gsm;
GardaMatt, 130 gsm

Publication © 2018
David Zwirner Books

First published 2018. Second
printing 2024

Text © 2018 Donald Shambroom

p. 49: The Getty Research Institute,
Los Angeles. Art © Man Ray Trust/
Artist Rights Society (ARS), NY/
ADAGP, Paris 2018
p. 50: Musee National d'Art Moderne,
Centre Georges Pompidou, Paris.
Photo: Guy Carrard © CNAC/MNAM/
Dist. RMN-Grand Palais/Art
Resource, NY. Art © Man Ray Trust/
Artist Rights Society (ARS), NY/
ADAGP, Paris 2018
p. 51: Art © Man Ray Trust/Artist
Rights Society (ARS), NY/ADAGP,
Paris/Telimage 2018

p. 52: The J. Paul Getty Museum,
Los Angeles. Digital image
courtesy of the Getty's Open
Content Program
p. 53: The J. Paul Getty Museum,
Los Angeles
p. 54: Art © Henri Cartier-Bresson/
Magnum Photos
p. 55: Art © Ira Nowinski

Distributed in the United States
and Canada by
Simon & Schuster, Inc.
1230 Avenue of the Americas
New York, New York 10020
simonandschuster.com

Distributed outside the
United States and Canada by
Thames & Hudson, Ltd.
181A High Holborn
London WC1V 7QX
thamesandhudson.com

ISBN 978-1-941701-87-4

Library of Congress
Control Number: 2018946882

Printed in Italy